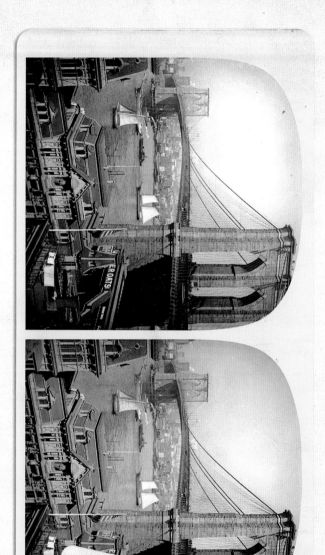

The longest suspension bridge in the world at the time, the Brooklyn Bridge opened in 1883.

THE
MARVELS OF
STEREOSCOPY
EXPLAINED

* * *

DESCRIBING DETAILS OF HOW

STEREOVIEWS WORK

AND INCIDENTS IN THEIR

AMAZING HISTORY

<p align="center">✸ ✸ ✸</p>

IN THE LONG-AGO DECADE OF THE 1850S, A MANIA FOR STEREOSCOPY flourished. Imagine, if you will, that the only images you had of the wide world were what you had seen yourself with your own two eyes. Newspapers and magazines printed only lithographs or engravings; photography was new and novel, a rich man's indulgence; moving picture films had yet to be invented. Then you were offered a stereoscope viewer and your choice of images, from the far-off pyramids of ancient Egypt to the fabled Great Wall of China. Peering through the viewer's lenses, suddenly the wonders of the world were there before you in all their three-dimensional glory. It was as if those sites and the people depicted were alive and breathing there in front of your own two eyes!

Stereoviews were the television or internet of the day. At the peak of their popularity from the 1850s through 1930s, a stereoscope viewer

and a carefully chosen collection of stereoviews boasted pride of place in most every middle- and upper-income household around the globe. Stereoviews offered entertainment, education, and armchair travel all in one. They were the virtual reality of their day and age.

The invention of stereoscopy coincided with our comprehension of the concepts of binocular vision and the separate development of photography. In 1838, British scientist Sir Charles Wheatstone presented a paper to the Royal Society demonstrating stereopsis and explaining that we perceive objects in three dimensions because each eye sees a slightly different view; our brains reconcile the two images into one three-dimensional image. Wheatstone unveiled a crude stereoscopic viewer using angled mirrors to look at

drawings. But it wasn't until the 1851 International Exhibition at London's Crystal Palace that everyday people could try out Scottish scientist Sir David Brewster's "improved" binocular stereoscope. Queen Victoria herself proclaimed the stereoscope a marvel of the highest order.

And thus the fad began. From the early 1850s to the late 1930s, millions of stereoscopic images were made by both commercial and amateur photographers. Famous publishers such as Underwood & Underwood, Keystone View Company, B. W. Kilburn, and many more soon began issuing stereoview collections. They documented famous personalities of the times, landmarks around the globe, bible stories brought to life, scientific principles from zoology to astronomy, cycloramas of historical occurrences, and the era's current news events, from the American Civil War and San Francisco's 1868 and 1906 earthquakes to the horrors of World War I. There were even risqué boudoir views available, if you knew who to ask.

Images were on sale at tourist attractions as souvenirs to wow the folk back home. Traveling salesmen carried their cases of wares from door to door, offering viewers and photos to discerning fans eagerly building their collections. Stereoviews provided many people their first photographic views of the world, and they became devoted fans.

By the 1930s, stereoscopy was suddenly old-fashioned and out of fashion. Newspapers now reproduced photographic images, and the new marvels of moving pictures and newsreels brought the world to people in the comfort of theater palaces. The wonders of those once-amazing stereoviews had been surpassed.

But here, in this album of near-forgotten stereoviews, the past lives and breathes once again—in 3D!

HOW TO USE THE STEREOSCOPE VIEWER
Relax, and Travel Back in Time!

IN THE EARLY DAYS OF STEREOSCOPY, PHOTOGRAPHERS CREATED the novelty of stereoviews by taking an initial photograph, then moving their camera slightly to a new position to snap the second image. Some inventive photographers soon crafted their own rigs with two, side-by-side cameras. Others used newfangled cameras with dual lenses spaced some 65 millimeters or 2½ inches apart—the distance separating the average person's pupils.

Looking through the lenses of a stereoscope viewer, the human brain recreates the three-dimensional view using the separate views seen with each eye. To do this, all you need do is relax!

To see the stereo image, do not force your eyes to look at the two separate images. Instead, begin by letting your eyes relax, looking above or below the images. Then, slowly move your eyes to the center of the images—and the two images will reappear in 3D. Once you have the images fused together into one, you can move your eyes around to examine different details of the picture and see it in all its depth.

If you wear glasses, try keeping them on while looking through the stereoviewer. The correction in your glasses is often necessary for you to focus on the images. But if it does not work, take off your glasses and try again.

If you're still having difficulties, try moving your head closer or further back from the lenses. You can also tilt your head left or right to adjust the horizontal alignment of the two images.

Simply relax in the comfort of your cozy parlor and prepare to be transported on a journey into the past with your collection of stereoviews and built-in viewer!

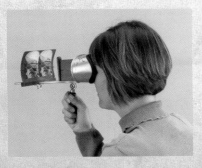 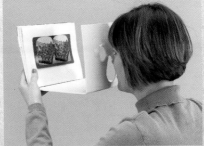

Pedestrians on Brooklyn Bridge

Walking across the Brooklyn Bridge along the promenade, at a cost of 1 cent, provides exciting views of Brooklyn, downtown Manhattan, and the East River. Since the bridge's opening by President Chester Arthur on May 23, 1883, pedestrians have enjoyed crossing the bridge from Brooklyn Heights to City Hall Park in lower Manhattan. The bridge cost $15.1 million, over twice the original estimate. At a total length of 6,016 feet, Brooklyn Bridge was the longest suspension bridge in the world until the construction of the Williamsburg Bridge in 1903, which was 4 1/2 feet longer. The bridge's cables appear to be delicate tendrils, but each is made of 5,296 galvanized steel wires; the total length of wire used was 14,357 miles. John Augustus Roebling, the engineer who designed the Brooklyn Bridge, was also the inventor of wire cable, patented in 1840.

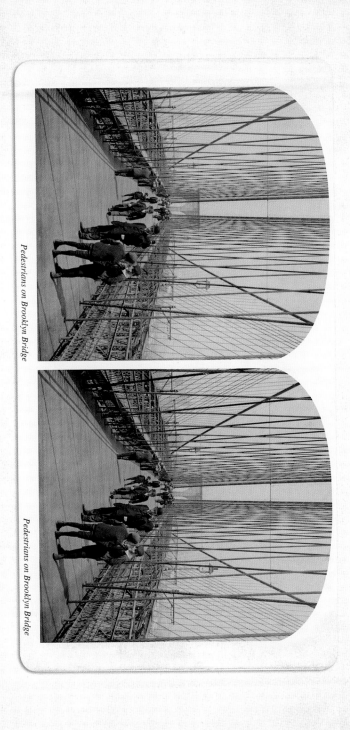

Pedestrians on Brooklyn Bridge

Pedestrians on Brooklyn Bridge

MANHATTAN SKYLINE FROM THE BROOKLYN BRIDGE

As seen through the mesh of the bridge's elegant cables, the Brooklyn Bridge across the East River provides the quintessential view of New York's cityscape. In 1855 civil engineer and owner of a wire rope company, John Roebling, proposed the building of a suspension bridge across the East River, having already designed and built the Niagara rail bridge and the Cincinnati Bridge. His project was finally approved and financed by 1869. Money for the bridge was raised through the private sector and funded by bonds issued by the cities of New York and Brooklyn. The first bridge over the East River, it enabled the growth of the outer suburbs of New York and connected the two, until-then-separate cities of New York and Brooklyn. With lower Manhattan skyscrapers competing to be the highest in the world, the bridge's patrons in the late nineteenth and early twentieth centuries were treated to a constantly evolving panorama at the forefront of modern architecture.

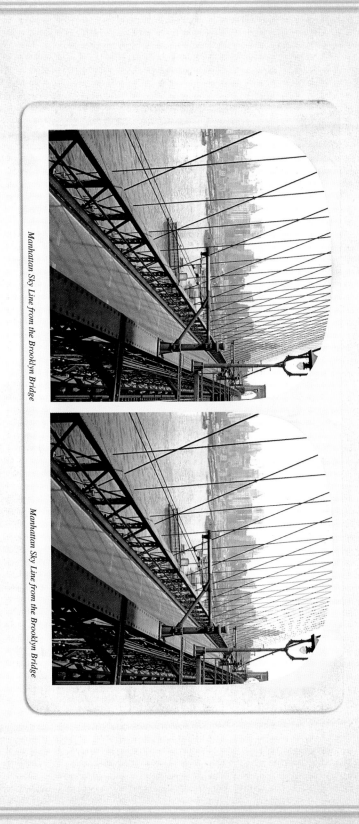

Manhattan Sky Line from the Brooklyn Bridge

Manhattan Sky Line from the Brooklyn Bridge

BUILDING THE BROOKLYN BRIDGE

Construction of the Brooklyn Bridge over the East River began in January 1870. Designed by civil engineer John Augustus Roebling, a German immigrant who had settled in Pittsburgh in 1831, and completed by his son Washington Roebling, the Brooklyn Bridge was the longest suspension bridge in the world when it was completed in 1883. The buttressed Gothic towers are built of solid granite and rise 272 feet from above the waterline into the sky; in many ways they were the first high-rise towers in New York. The bridge's four suspension cables are capable of sustaining a live load of twelve thousand tons each. The Roeblings, father and son, paid a heavy personal price for their legacy: John's foot was crushed against a pier while he was examining the site and he died of tetanus from the injuries, while decompression sickness from repeatedly working in compressed air beneath the river left Washington paralyzed. His wife Emily, who had studied bridge engineering and higher mathematics, oversaw the project for him.

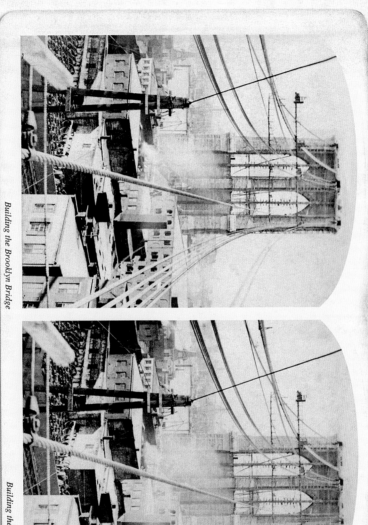

Building the Brooklyn Bridge

Building the Brooklyn Bridge

Looking North from South Ferry

As businesses and residences spread uptown during the nineteenth century, transportation was developed to keep up with the needs of moving people from place to place within the city. Elevated railroad lines were the precursors of New York's subway system. In 1878, the Third Avenue line was opened using steam engines running on standard-gauge rails. Run by the New York Elevated Railroad Company, this line spanned from its southern terminus at South Ferry at the lower tip of Manhattan to the upper Bronx. Called the "El," more lines were added to the system late in the nineteenth century, transforming the lives of New Yorkers and enabling the growth of the outer suburbs and quicker and more economical movement of trade and goods.

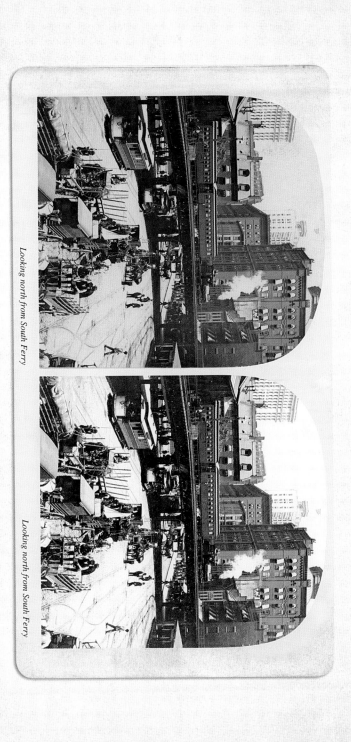

Looking north from South Ferry

Looking north from South Ferry

Park Row from Tryon Row

This intersection of streets in lower Manhattan, including Tryon Row running between Centre Street and Park Row, shows the street alive with streetcars, carriages, and pedestrians. On the right is City Hall Park, with City Hall, built between 1803 and 1812, situated within it. This neighborhood featured the offices of many newspapers so that the reporters would be close to the goings-on at City Hall. The Times Building at 41 Park Row was the first building in New York to be constructed specifically for a newspaper and was notable for its running strip of lights that brought world news directly to the streets of New York.

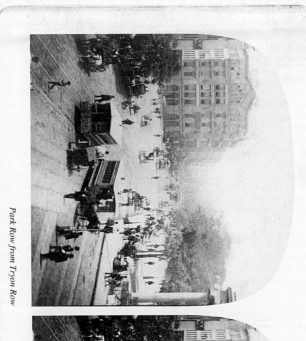

Park Row from Tryon Row

Park Row from Tryon Row

Lower Broadway

As image technology advanced in the nineteenth century, photographers were able to capture the vibrancy of city life — pedestrians and horse-drawn carriages filling the streets lined with shops and entertainments. The new practice of capturing a slice of time and interaction was called "instantaneous photography." Firms such as Anthony Brothers and C. W. Woodward capitalized on the shift from still lifes, lone buildings, and stolid portraits to bustling street scenes and life in action. Lower Broadway is the oldest north-south thoroughfare in New York and dates from the time of the Dutch settlement of New Amsterdam. It runs the full length of Manhattan from Bowling Green in the south all the way into the Bronx and parts of it were widened and paved in the late nineteenth century.

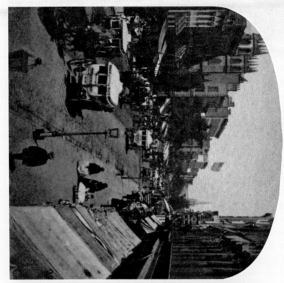

Lower Broadway

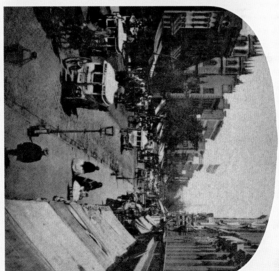

Lower Broadway

CASTLE GARDEN—NEW YORK HARBOR

Castle Clinton was built as a fort for the defense of New York Harbor during the War of 1812. It was later repurposed for diverse other uses under the name Castle Garden. For a while it was the venue for public entertainments such as band concerts, scientific demonstrations, and, on September 11, 1850, a famous performance by Jenny Lind, known as the "Swedish Nightingale." She was so delighted with her reception from New Yorkers that she donated the significant profits from the concert to local New York charities. From 1855 to 1890, Castle Garden served as an arrival center for immigrants. The New York City Aquarium opened here in 1896, housing an assortment of sea creatures, including sharks, giant morays, penguins, and alligators. South of the castle, boats share New York Harbor with the Statue of Liberty, sculpted by Frederic Auguste Bartholdi and unveiled in New York in 1886.

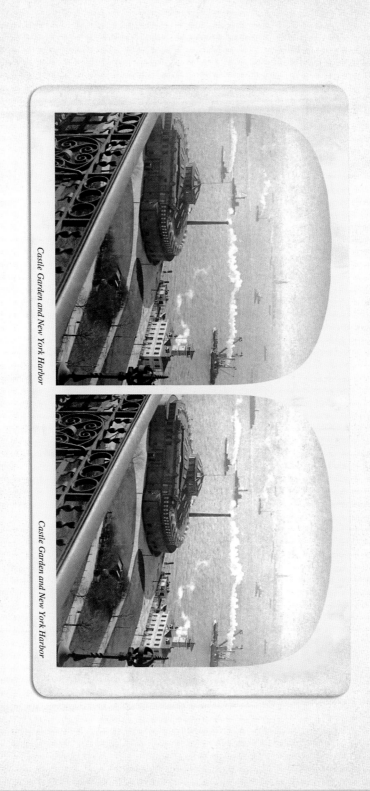

Castle Garden and New York Harbor

Castle Garden and New York Harbor

St. Paul's Chapel

Completed in 1766, St. Paul's, the chapel of Trinity Church, is built of Manhattan mica-schist on land granted by Queen Anne and is the oldest church in Manhattan. The chapel's octagonal tower is a replica of the Choragic Monument of Lysicrates. On his inauguration day, April 30, 1789, George Washington, and members of the United States Congress, worshipped at St. Paul's because New York City was at the time the capital of the United States. Until 1904 New Yorkers gathered at the Gothic revival–style Trinity Church to celebrate New Year's Eve and the passing of the old year into the new. Behind the church lies the U.S. Realty Buildings and Trinity Building, both twenty-one-story-high office buildings.

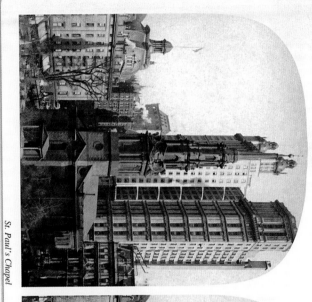

St. Paul's Chapel

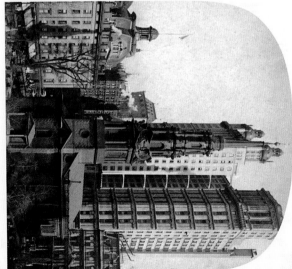

St. Paul's Chapel

The Woolworth Building, Cathedral of Commerce

Commissioned by Frank W. Woolworth, the five-and-dime store magnate, the Woolworth Building was designed by architect Cass Gilbert in a neo-Gothic style complete with Gothic tracery and gargoyles and became a masterpiece of New York City skyscrapers. Woolworth wanted his building to be the tallest in New York, and the world, and to accomplish this it had to surpass the 700-foot-tall Metropolitan Tower at Madison Square. Located on Broadway, between Park Place and Barclay Street, the Woolworth Building reached 792 feet high and was the tallest building in the world bar the Eiffel Tower in Paris. It was built at a cost of $13.5 million, which Mr. Woolworth famously paid for in cash. The magnificent lobby is made of marble and features a fabulous glass mosaic ceiling.

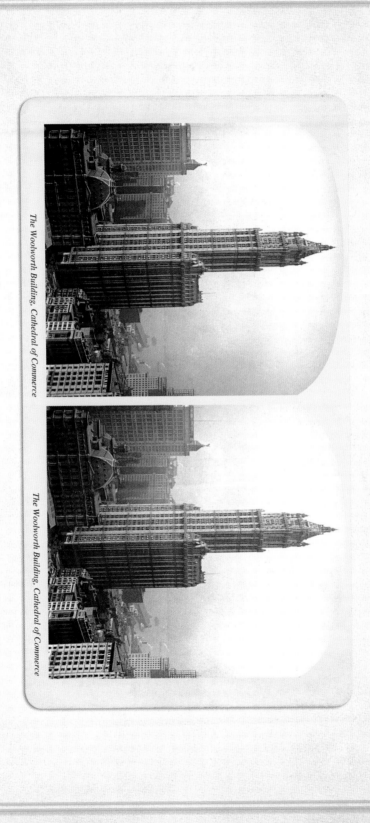

The Woolworth Building, Cathedral of Commerce

The Woolworth Building, Cathedral of Commerce

Looking North on Broadway past Trinity Church

Often called the "canyon" of Broadway, the towers of New York's early high-rise commercial buildings border the avenue. In the mid nineteenth century the thoroughfare started to split its character, with the streets below City Hall tending to house offices and businesses, while northward elegant shops and theaters started to appear. The Empire Building at 71 Broadway, at the corner of Rector Street, opened in the early 1850s and housed offices and stores. In the foreground is the soaring neo-Gothic spire of Trinity Church which when it was consecrated in May 1846 dominated the skyline of lower Manhattan. The gilded cross at the pinnacle was a welcome homecoming sign for returning ships in New York Harbor, but the view was soon swallowed up and hidden by the rising skyscrapers.

Looking North on Broadway past Trinity Church

Looking North on Broadway past Trinity Church

Bowling Green and Broadway from Battery Place

Bowling Green, the oldest of New York City's parks, is a small area of green located at the tip of Broadway in lower Manhattan and was originally a cattle market area and parade ground. It was designated as a park in 1733 next to the site of the original Dutch fort of New Amsterdam on condition that it would be to "the delight of the Inhabitants of the City" and would include a bowling green. The park's plaza has been used since the seventeenth century, when according to legend, it was the location of the sale of Manhattan to Peter Minuit in 1626. Throughout the revolutionary period, the park was the site of numerous incidents. A large lead equestrian statue of King George III, erected in the park in 1770, was knocked down on July 9, 1776 by a contingent of the Sons of Liberty following the first public reading in New York State of the Declaration of Independence. After the Revolution the remains of the fort were demolished and much of the rubble was used to extend the Battery westward.

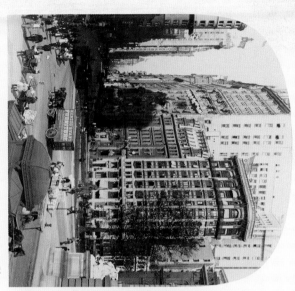

Bowling Green and Broadway from Battery Place

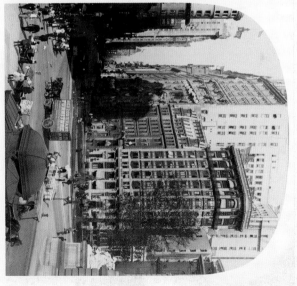

Bowling Green and Broadway from Battery Place

Travelling the Bowery

This road originally connected a series of Dutch-settled farms, called "boweries," and before even that was a Native American trail running roughly north-south across Manhattan Island. New York's numerous modes of transportation are seen along the Bowery, the oldest thoroughfare through Manhattan. Along the street's four lanes run streetcars, horse-drawn carriages, and carts conveying both people and goods to their destinations. Above, a steam train runs on the elevated tracks while foot traffic perambulates beneath it. In the mid nineteenth century, the Bowery was the neighborhood of one of New York's earliest street gangs, the notorious anti-Irish, anti-Catholic Bowery Boys, who dressed in black trousers with red shirts and wore stovepipe hats over their slicked-back hair.

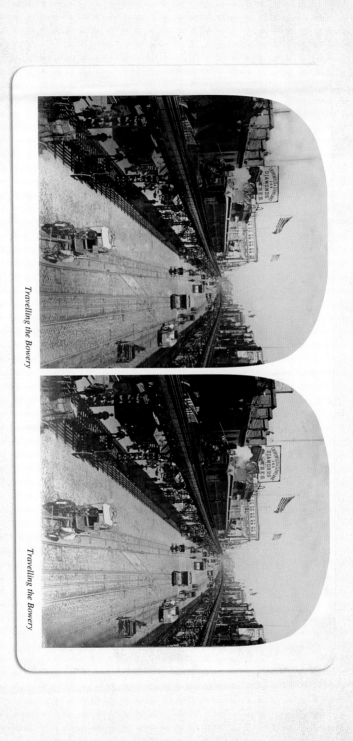

Travelling the Bowery

Travelling the Bowery

Shopping the Bowery

The buildings of the Bowery house many sorts of entertainments including theaters, beer halls, and shops. As Manhattan life moved uptown, many businesses moved from the Bowery to the more fashionable Union Square area. The C & C sign, at 144 Bowery, announces the jewelry business of Casperfeld & Cleveland. When asked in an 1899 interview if the location of his shop hurt business, Mr. Casperfeld replied, "Not at all. You must remember that we have always been here, and a great many monied visitors to New York come to see the Bowery." In the 1840s a forty-block area east of the Bowery and north of Division Street attracted German immigrants became known as "*Kleindeutschland*" (Little Germany) and filled with German shops and businesses.

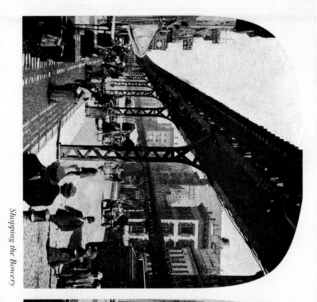

Shopping the Bowery

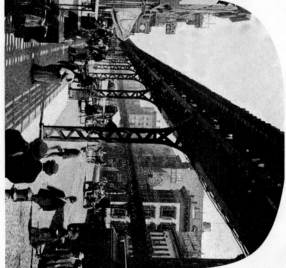

Shopping the Bowery

Barnum's Museum after the Fire

This photograph was taken the day after a spectacular fire on March 3, 1868 destroyed P. T. Barnum's American Museum located at the corner of Broadway and Ann Street. Icicles hang from the broken windows and burnt out façade, frozen from the cold of the day and giving an eerie effect to the building's ruins. Following a previous fire at Barnum's original museum in lower Manhattan in 1865, the museum was moved to this second location where at its peak it attracted fifteen thousand visitors a day. Barnum's Museum displayed the showman's brand of freak shows, a wax museum, animals, and all sorts of curiosities. Survivors of the fire included all of the persons inside—including the giantess Miss Swann and the albino twins—but most of the animals on display were not so fortunate. Barnum tried to open another museum, but it too burnt down so he decided to create his own circus and tour the country.

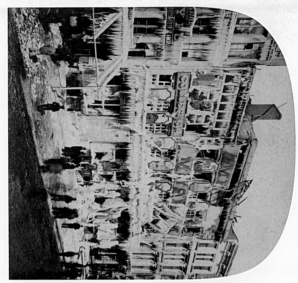

Barnum's Museum after the fire

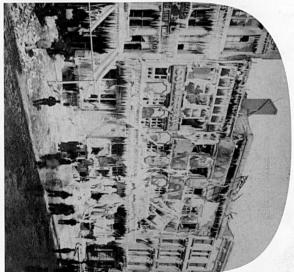

Barnum's Museum after the fire

Immigrants Arriving at Ellis Island

Opened on January 1, 1892, Ellis Island in New York Harbor served as the major portal for European immigrants as they arrived in the United States. New would-be citizens would land by ferry at Ellis Island's main building to face exacting medical and legal examinations before being allowed entry to the United States. About two percent were rejected. Annie Moore, a fifteen-year-old girl from Ireland, was the first immigrant to arrive at Ellis Island when she came to New York to join her parents. In 1907 Ellis Island had its record year when the authorities there processed 1,004,756 people; the busiest day was April 17 when 11,747 immigrants arrived. The sick were sent to a hospital on the island to recuperate, but long-term patients or those with serious diseases or criminal records were sent home as was anyone "likely to become a public charge." Families could be faced with the awful choice of returning together to Europe or abandoning a member of the family if entry was refused to one of their number.

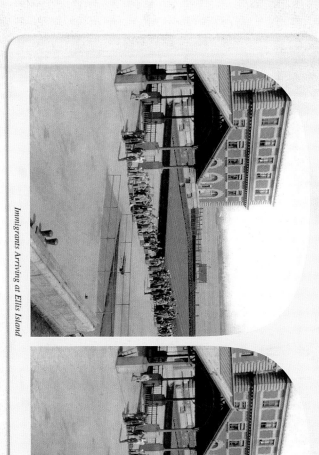

Immigrants Arriving at Ellis Island

Immigrants Arriving at Ellis Island

Peddlers on Elizabeth Street

Peddlers on the busy streets of New York's Lower East Side sell wares and provisions of all types from their carts and wagons. Pedestrians emerge from the neighborhood tenement buildings, filling the sidewalks to peruse the offerings from numerous vendors. Elizabeth, Orchard, Delancey, Hester, Essex, and other streets that comprise the Lower East Side created the hub of city life for most of New York's immigrants. The Lower East Side was one of the most densely populated urban areas in the world in the late nineteenth and early twentieth century. Additional tenements were routinely inserted behind city lots, shoddily built of wood and salvaged materials; the cramped, dark, and dank conditions only aggravated the already pitiable state of many poor, unemployed, and sick immigrants. Characteristic of the tenements were the lines of washing hanging from the windows, but despite the residents' attempts at cleanliness they were plagued by lice and vermin. The stench from the inadequate sewerage provisions mingled with various ethnic food smells gave the slums an unmistakable stink.

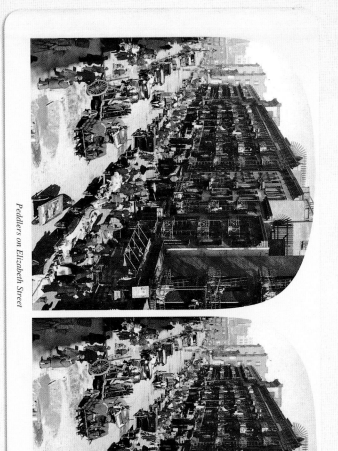

Peddlers on Elizabeth Street

Peddlers on Elizabeth Street

Tenements in the Lower East Side

As immigrants poured into New York in the late nineteenth century, many made their first homes in Manhattan's Lower East Side. Tenement buildings housed extended families as they settled into New York. More relatives often arrived unexpectedly, overcrowding the modest buildings that provided a start for people building a new life in America. The tenements of New York were a solution to the nineteenth-century housing crisis and greatly increased the density of buildings and population. They rapidly declined into slums rife with disease and crime. By 1864 there were fifteen thousand tenements in the city and the authorities at last attempted to control their unregulated building, particularly with regard to sanitation requirements and living density. The Metropolitan Board of Health was established to oversee the problem and improve general housing conditions for the poor and underprivileged.

Tenements in the Lower East Side

Tenements in the Lower East Side

Free Reading Room

Before the development of New York's public libraries at the end of the nineteenth century, various New York institutions and benefactors created free reading rooms for the benefit of New York's growing population. The Boys Free Reading Room and the Working Men's Free Reading Room were two places where men, after working through the day, would come to read the day's papers, satisfying their needs for information of all sorts and scouring the dailies for news from their homelands. It was with the substantial aid of Samuel J. Tilden's bequest, following his death in 1886, to "establish and maintain a free library and reading room in the city of New York," that the New York Public Library was established. In the late 1850s the Free Reading Room and Library opened at 135 Greenwich Street for the residents of lower New York. The library was supported by voluntary subscriptions from local merchants, lawyers, and bankers and opened on Sundays from 3 p.m. to 10 p.m., when it offered access to around one thousand books.

Free Reading Room

Free Reading Room

Building the Williamsburg Bridge

The second bridge built over the East River, the Williamsburg Bridge, connects the Lower East Side of Manhattan to Williamsburg, Brooklyn on Long Island. The bridge, designed by chief engineer Leffert Lefferts Buck, took seven years to build, from 1896 when construction began until its completion in 1903 at a cost of some $12 million. When it opened, the Williamsburg Bridge was the longest suspension bridge in the world and the first all steel, large-scale bridge. This view shows the construction at a point when the main cables are in place, but the deck for trains, carriages, and later automobiles, is not yet in place. The steel was spun by John A. Roebling Sons Inc., the firm started by the designer of the Brooklyn Bridge. The bridge's suspension cables span 1,600 feet and hang from thirty-five-story steel towers. The bridge originally had four streetcar tracks and two elevated regular train tracks, but scheduled train services did not start until 1908.

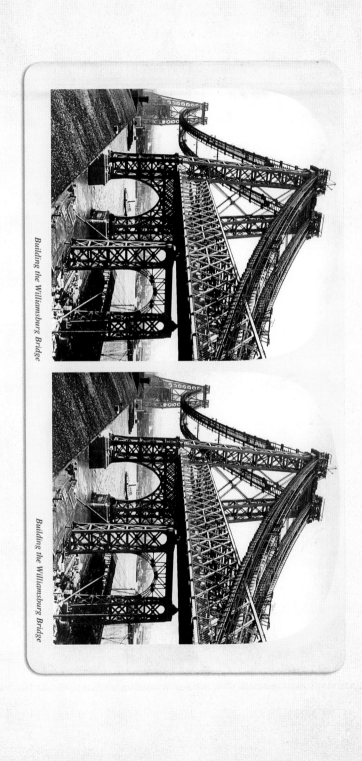

Building the Williamsburg Bridge

Building the Williamsburg Bridge

Bathers at Coney Island

A trip to Coney Island offered a day's respite from the city's often oppressive summer heat. Coney Island hits its peak popularity after 1895 when Captain Paul Boyton's Sea Lion Park opened and public transport became more accessible. Initially the easiest access from New York was by scheduled steamboat, costing 50 cents from the Battery, a trip which took around two hours. Then in the 1870s the railroad across Brooklyn opened and New Yorkers by the thousand descended on Coney Island. The beaches were packed with bathers, who shared the cooling waters with their fellow city dwellers. The entertainments of Coney Island extended beyond the beach to its popular arcades. The eastern end of the island was the smartest with elegant hotels and mansions. In the center was the Brighton Beach Hotel, the Public Bathing Pavilion, and the Iron Pier. The roughest area was Norton's Point at the western end where the gambling dens and prostitutes made their living. At nearby West Brighton were the dancing pavilions, saloons, amusement piers, amusement parks, and restaurants. The first roller coaster opened in 1884 and drew eighty thousand visitors its first year.

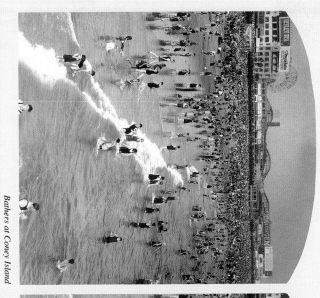

Bathers at Coney Island

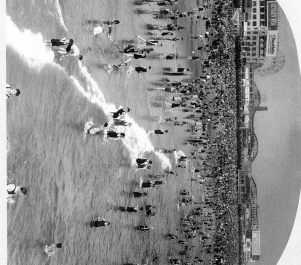

Bathers at Coney Island

Bathers at the Photo Tent, Coney Island

On the Atlantic shore of Brooklyn, Coney Island offered a rare opportunity for New Yorkers to enjoy all the fun of the seaside with sandy beaches, rides, and swimming in the sea among the many attractions. And for those wanting a souvenir photo of the day there was the Photo Tent. Here some young girls take a break from bathing to wait in line for their turn to capture a memory of their special day. Bathhouse and costume rental cost 25 cents, for which the ladies would get knee-length pantaloons held up by suspenders and a long-sleeved, dark wool blouse, stockings, and bathing shoes. Sea bathing began to become popular in the 1850s and 1860s when it was promoted as a healthy pursuit. By 1869 the wealthy had abandoned Coney Island to the "rougher class" and Coney Island became the "great democratic resort—the ocean bathtub of the great unwashed."

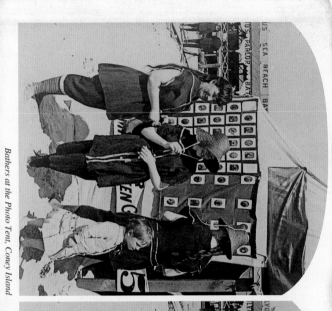

Bathers at the Photo Tent, Coney Island

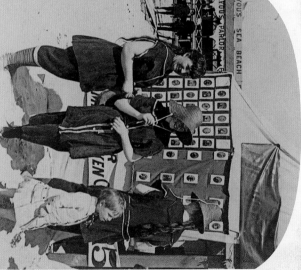

Bathers at the Photo Tent, Coney Island

Luna Park at Night, Coney Island

A trip to Coney Island was worth it just for the amazing sight of the lights of Luna Park. Even by day the exciting exoticism of Luna Park drew crowds in the thousands. Frederic Thompson and Elmer "Skip" Dundy created Luna Park after they bought out Sea Lion Park. They pulled it all down except the Shoot-the-Chutes ride and built their new attraction over the winter of 1902–1903. Luna Park opened on May 16, 1903 and dazzled with 250,000 lights, 100,000 of which were on the Electric Tower. Additional glitter came from the park's spires and minarets, and all the lights were a particular novelty at a time when electricity was still relatively new. For between 10 cents and 15 cents the park offered family entertainment, rides, vaudeville, and exhibitions. In 1907 the Russian writer Maxim Gorky wrote of Luna Park that it was "Fabulous beyond conceiving, ineffably beautiful, is this fiery scintillation."

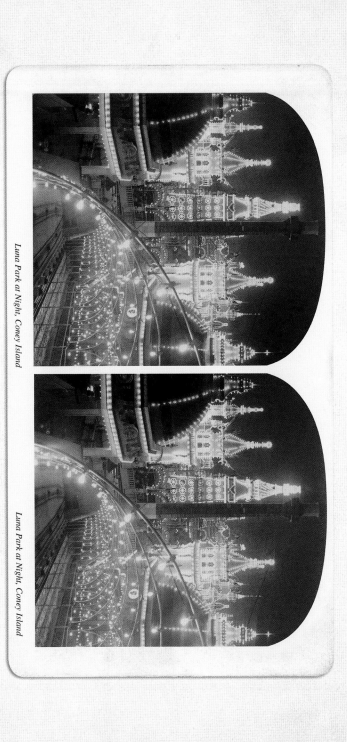

Luna Park at Night, Coney Island

Luna Park at Night, Coney Island

Drinking Fountain, Prospect Park

In the nineteenth century, Brooklyn changed from farmlands to row houses and in 1898 Brooklyn became a part of New York City. Part of Brooklyn's growth included the creation of Prospect Park, which had been the location of the Battle of Long Island in August 1776. Following the success of Central Park in Manhattan, Brooklyn residents began planning a grand park of their own. Following a design by Central Park designers Frederick Law Olmsted and Calvert Vaux, construction of Prospect Park began in 1866. The park covers 585 acres with winding pathways, meadows, woodlands, carriage drives, and waterfalls that create a respite for city residents to relax in a natural setting. In the late nineteenth century a number of neoclassical additions were made to the park including impressive entrances, the Memorial Arch at Grand Army Plaza with four huge elaborately carved granite columns, granite pavilions at the east and west corners, sculptures, and many other structures.

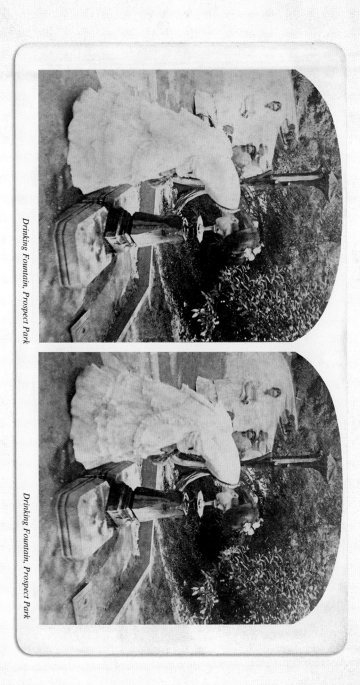

Drinking Fountain, Prospect Park

Drinking Fountain, Prospect Park

Monuments in Green-Wood Cemetery

Green-Wood Cemetery, established in 1838, sits on 478 acres in Brooklyn. This rural cemetery, with its many notable late nineteenth century permanent residents—including many members of the Roosevelt family and Samuel C. Reid, the first designer of the Stars and Stripes—has been a tourist destination since the nineteenth century. The cemetery was designed with winding paths, trees, and lakes and served not only as a burial place but also as one of the city's early landscaped greeneries for strolls and picnics. In its day it was the fashionable place to be buried and is full of fantastic Gothic monuments, statues, obelisks, mausoleums, and memorials. By 1860 around 500,000 visitors were coming every year to enjoy a family day out with carriage rides in the fresh country air. The popularity of Green-Wood helped to inspire the creation of public parks, particularly Central Park and Prospect Park in New York City.

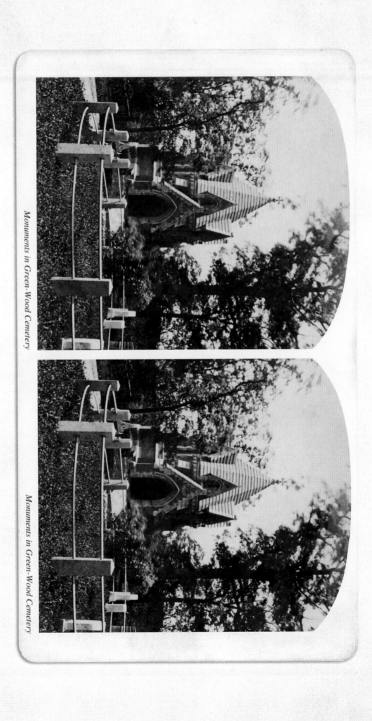

Monuments in Green-Wood Cemetery

Monuments in Green-Wood Cemetery

Lincoln's Funeral, Union Square April 24–25, 1865

Following President Abraham Lincoln's death, his body was brought from Washington, D.C. to Springfield, Illinois by train with numerous stops along the way. The train reached New York on April 24 and the casket was placed in City Hall where an estimated 120,000 mourners paid their respects. The next day, April 25, with the city shut down, the procession carried Lincoln's body through the streets from Broadway to 14th Street, where the procession stopped at Union Square for prayers, a funeral oration, and the reading of William Cullen Bryant's "Funeral Ode to Abraham Lincoln." From there the procession led to the Hudson River Railway Depot at 34th Street and Ninth Avenue where the coffin was placed on the special train. With over half a million viewers along the route, "There was no cheering, no waving of flags, no clapping of hands, no lively strains of martial music. Instead of these were substituted emblems of sorrow and lamentations."

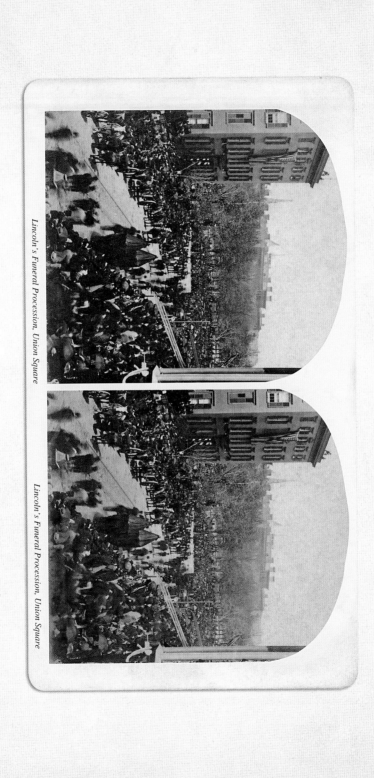

Lincoln's Funeral Procession, Union Square

Lincoln's Funeral Procession, Union Square

Lincoln Monument at Union Square on Decoration Day

The bronze statue of Lincoln at Union Square is bedecked for May 30, Decoration Day (later Memorial Day), chosen for the date of reunification after the Civil War and first observed in 1865. This larger than life bronze monument of Lincoln was designed by Henry Kirk Brown in 1868 and was dedicated on September 16, 1870. It was commissioned and sponsored by the Republican Union League Club and cast in Philadelphia. The statue presents Lincoln classically draped in an elegant pose and was originally situated in the street bed at the southwest corner of Union Square. A few years later in 1875 the monument was encircled by bronze railings on top of a stone wall which was inscribed with the words from Lincoln's second inaugural address, "... with malice towards none; charity toward all." Mr. Brown also sculpted a second, similar monument to Lincoln that was erected in Brooklyn's Prospect Park. In 1860, Lincoln spoke at Cooper Union a few blocks south of Union Square, uttering one of his most quoted phrases, "right makes might."

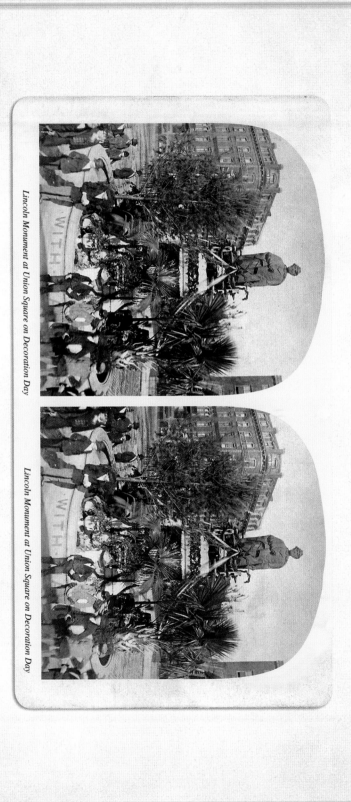

Lincoln Monument at Union Square on Decoration Day

Lincoln Monument at Union Square on Decoration Day

Metropolitan Fair on 14th Street

Fashionable women, under the lawful watch of New York's police force, stroll along 14th Street to attend the Metropolitan Fair. Walking on the city's sidewalks, constructed of bluestone from upstate quarries, New Yorkers attending the fair got to see and enjoy many fabulous displays. The Metropolitan Fair, sponsored by the United States Sanitary Commission (USSC), opened March 28, 1864 to raise money for the care of sick and wounded soldiers. The fair's many buildings housed displays of agriculture, trade, and art including wax flowers, fancy goods, sewing machines, and arms and trophies. New York's fair raised nearly $1.2 million. Significantly, the immense popularity of the Picture Gallery at the fair sparked the demand for a museum in New York to rival those of Europe. Accordingly, a committee was formed and in 1870 the Metropolitan Museum opened.

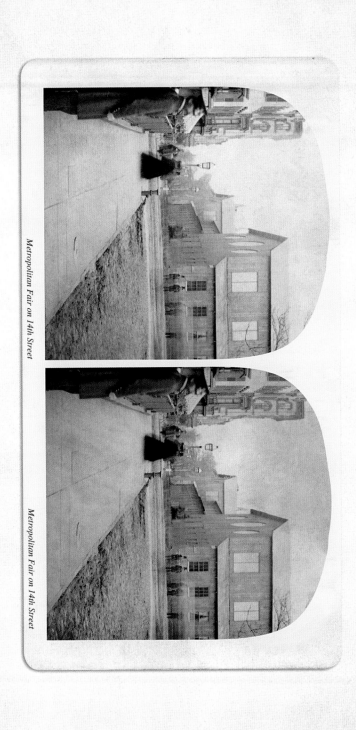

Metropolitan Fair on 14th Street

Metropolitan Fair on 14th Street

The Christopher Columbus Arch

Celebrations in 1892 to honor the quadricentennial anniversary of Columbus's discovery of America included a plan for an arch to be built at 59th Street and Fifth Avenue at the entrance to Central Park. Following a competition, the winning arch, designed by Henry B. Hertz, a twenty-one-year-old architecture student at Columbia College, was constructed as a temporary structure with the plan, later unrealized, of raising funds to build a permanent monument. The arch's elaborate design features fountains; allegorical motifs of Victory, Immortality and Discovery; scenes in homage to Columbus; and the inscription: "The United States of America, in Memorial Glorious to Christopher Columbus, Discoverer of America." Between October 9 and October 15, 1892, various events were held, including a naval spectacle on the Hudson River and on October 12 the highlight of the celebrations, a "grand military procession" of sailors, soldiers, police, and firemen marching in an eight-hour parade.

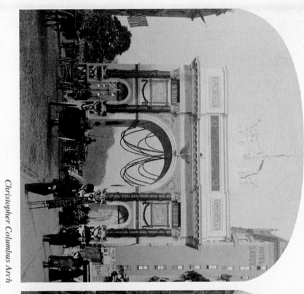

Christopher Columbus Arch

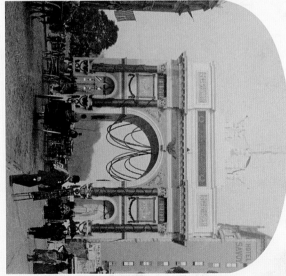

Christopher Columbus Arch

Madison Square

After the 1880s, Madison Square was an important, bustling business area of New York City where many important hotels were located. Madison Park, situated between Madison and Fifth Avenues and extending from 23rd Street to 26th Street, provides greenery among the area's buildings. Madison Square Garden gets its name from its early proximity to this park. The first Madison Square Garden was built in 1879 at 26th Street and Madison Avenue and held ten thousand seated spectators around an oval banked arena mainly used for the extremely popular sport of bicycle racing, in which big sums of money could be won: the races here were the most important in the country. The arena also staged boxing matches and circuses. In 1890 the second, much grander, Madison Square Garden at Fifth Avenue and 26th Street was designed by Stanford White in Moorish style with a tower somewhat like a minaret, in homage to the Giralda tower in Sevilla, and topped with a nude statue of the goddess Diana. This held up to eight thousand spectators and was home to sporting events, political speeches, concerts, theatrical productions, automobile parades, and aquatic shows.

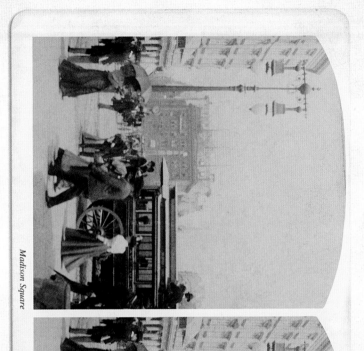

Madison Square

Madison Square

Ladies' Mile—Broadway

As seen from 18th Street, in the heart of Ladies' Mile, Broadway bustles with businesses and storefronts including the East River National Bank and Bouton Bookseller. The Ladies' Mile was the most fashionable and elegant shopping area of New York in the second half of the nineteenth century, where large department and luxury goods stores lined Broadway from Union Square to Madison Park. Famous store names such as Bergdorf Goodman, B. Altman, Lord & Taylor, W. & J. Sloane, and Best & Company attracted lady shoppers and celebrities from all over the city and well beyond until around the turn of the century when Ladies' Mile became somewhat run-down and the fashionable ladies moved to shop elsewhere. Broadway itself is one of New York's major thoroughfares and runs through all of Manhattan, into the Bronx, and north to Albany.

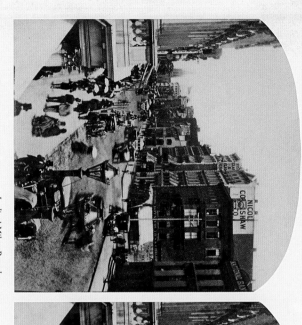

Ladies' Mile - Broadway

Ladies' Mile - Broadway

An Elegant Dining Room

Along with the city's monuments and street life, photographers also captured scenes of daily life inside some of the city's grand homes. While not as common as outdoor photography, numerous photographers, such as E. C. Thompson who made this image, offered their services including stereo photography to wealthy clients. Here the dining table is laden with silver, china, and glassware; these along with the pictures and the room's other features display the new pride in American interior decorations. Many of these furnishings were available on Ladies' Mile bought from the fashionable new department stores and specialist suppliers of luxury goods such as Tiffany & Company, founded in New York in 1837 as a "stationery and fancy goods emporium." 1865 to 1901 is known as the Gilded Age, when the newly rich financiers and industrialists—such as Cornelius Vanderbilt, Andrew Carnegie, J. P. Morgan, and Henry Rockefeller—enjoyed profligate displays of wealth, particularly in the construction of opulent neo-Renaissance buildings.

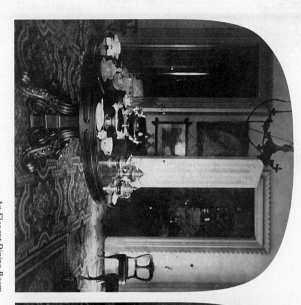

An Elegant Dining Room

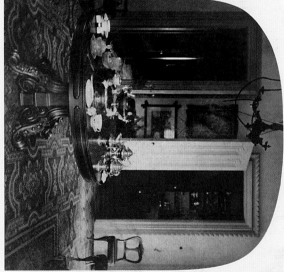

An Elegant Dining Room

The Flatiron Building

Sitting on a triangular plot at 175 Fifth Avenue, at the junction of 23rd Street, Fifth Avenue, and Broadway at the southern end of Madison Square, the Flatiron Building quickly became an icon of New York City architecture. Designed by Chicago architect and skyscraper pioneer Daniel H. Burnham, the building was completed and opened in 1902 and was originally called the Fuller Building after its first occupants. At the time it was one of the tallest buildings in New York with twenty-two stories rising up 286 feet. Built in a retail and residential area, the building was an attempt by speculators to create a new business center north of Wall Street and offered offices for rental to various businesses. It quickly became a favorite of New Yorkers who affectionately dubbed it the Flatiron Building for its quirky shape. One of the first skyscrapers in New York, the building's inner steel core is covered by a Beaux-Arts–style façade of richly decorated limestone up to the fourth floor and glazed terracotta from the fifth to the top. The Flatiron is one of the most photographed buildings in New York, including famous images by Alfred Stieglitz, Edward Steichen, and countless others to this day.

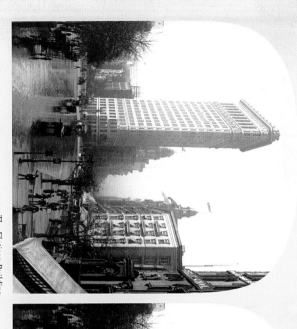

The Flatiron Building

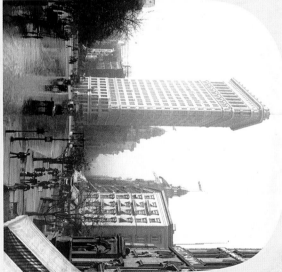

The Flatiron Building

Bird's-eye View of Madison Square

Workmen on the Metropolitan Life Tower view the greenery of Madison Square Park from their bird's-eye view high above the city. The Metropolitan Tower at One Madison Avenue was the tallest building in the world when it was completed in 1913, but soon surrendered that distinction to a New York sister, the Woolworth Building. Designed by Napoleon LeBrun & Sons as the headquarters of the Metropolitan Life Insurance Company, the tower was 700 feet high. It was clad with Tuckahoe marble and features a clock on each of its four sides; each clock is twenty-six and a half feet in diameter and each number four feet tall, while the minute hand weighs half a ton. Madison Square Park provides a refuge from one of the city's most dense commercial districts and is bordered by Fifth and Madison Avenues and 23rd and 26th Street. Between 1876 and 1882 Madison Square Park displayed the right arm and torch of the Statue of Liberty in order to publicize the statue and to raise money for its construction.

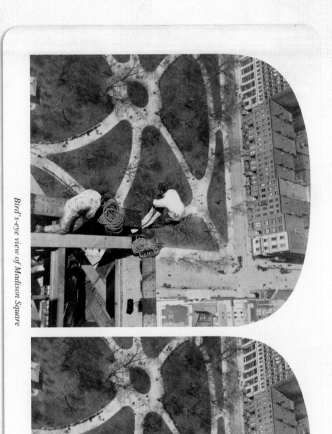

Bird's-eye view of Madison Square

Bird's-eye view of Madison Square

Interior of Grand Central Depot

These train tracks below an enormous vaulted ceiling were part of Grand Central Depot. Built by Cornelius Vanderbilt on land he bought bordered by 42nd and 48th Streets and Lexington and Madison Avenues and designed by architect John B. Snook, the station cost $6.4 million and opened in October 1871. The depot was constructed to consolidate the workings of three train companies—the New York Central and Hudson River Railroad, New York and Harlem Railroad, and the New York, New Haven, and Hartford Railroad—although each kept their separate baggage facilities, waiting rooms, and ticketing operations. The depot copied two European track innovations: the roof was a balloon shed with a clear span over all the tracks and the platforms were built up to the level of the railroad cars. Unfortunately the building was considered obsolete from the moment it opened due to the latest developments with electric engines. On January 4, 1877 a heavy blizzard caused the glass roof to collapse on exactly the same day its progenitor, Cornelius Vanderbilt, died. After a fatal train collision in 1902 the depot was demolished and replaced by Grand Central Station, which opened to great acclaim in 1913.

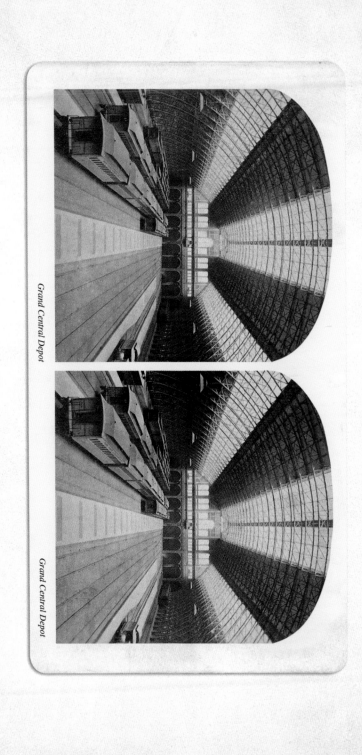

Grand Central Depot

Grand Central Depot

Fifth Avenue, North, Looking Toward Central Park

Along New York's luxury thoroughfare of Fifth Avenue, crowds gather before St. Patrick's Cathedral. Pedestrians, carriages, and cyclists go up and down the avenue past the stately homes of the Vanderbilts and other wealthy New Yorkers. The towers of St. Patrick's Cathedral were built in 1888. Fifth Avenue has been a desirable address since around the mid nineteenth century when wealthy New Yorkers started to build their mansions in the neighborhood. Its residential heyday owed much to the Astor family, who built houses along the avenue in the 1850s. In 1862 Caroline Schermerhorn Astor made her home at the corner of 34th Street and Fifth Avenue, but in 1893 her building was demolished and replaced by the Astoria Hotel. Fifth Avenue became even more prestigious after the purchase and early improvement of Central Park.

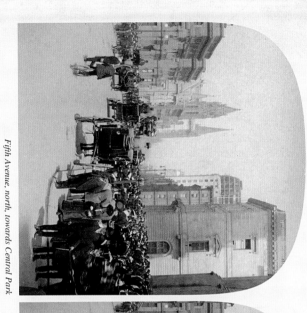

Fifth Avenue, north, towards Central Park

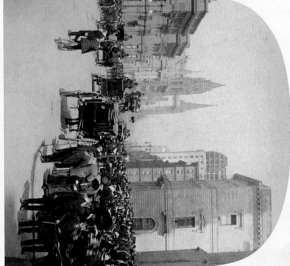

Fifth Avenue, north, towards Central Park

Interior of St. Patrick's Cathedral

St. Patrick's Cathedral, on Fifth Avenue between 50th and 51st Street, was dedicated on May 25, 1879 and is the seat of the Roman Catholic archbishop of New York. The Diocese of New York was created in 1808 and became an archdiocese thanks to Pope Pius IX in 1850. Old St. Patrick's Cathedral in downtown Manhattan was not thought grand enough for this new status and the decision to build a new and much more magnificent St. Patrick's Cathedral was made. The chosen design was in the Gothic Revival style and executed by James Renwick, Jr. Building work started in 1858 but was interrupted by the Civil War and did not resume again until 1865. The exterior is built of white marble quarried from New York and Massachusetts. This interior, with a view to the high altar, depicts a taste of the cathedral's grandeur and magnificence. It can accommodate 2,200 worshippers.

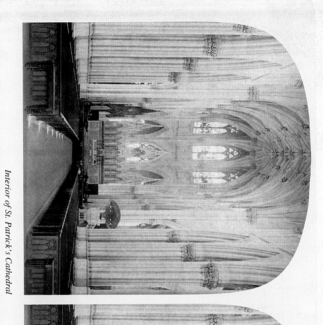

Interior of St. Patrick's Cathedral

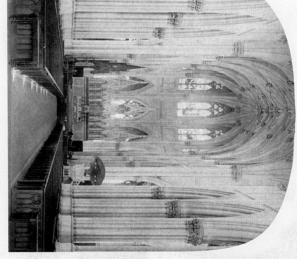

Interior of St. Patrick's Cathedral

Lover's Lane, Central Park

In 1857, New York city commissioners held a design competition for Central Park, the country's first public landscaped park. The winning design by Frederick Law Olmsted and Calvert Vaux, known as the Greensward Plan, is an urban planning success recognized around the world and much appreciated by New Yorkers over the generations. The park's many gardens and paths provide lovely places for leisurely strolls with friends and lovers and carriage rides. Lover's Lane, defined by its arched colonnade of trees, is a long straight walk that disguises the southern and western walls of the reservoir. It is an inviting place for promenades and intimate conversations where a man may tip his hat to a lovely woman largely unobserved by passersby.

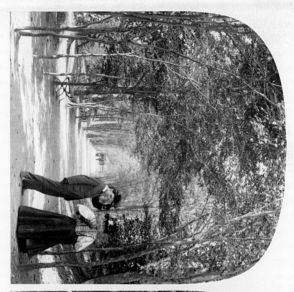

Lover's Lane, Central Park

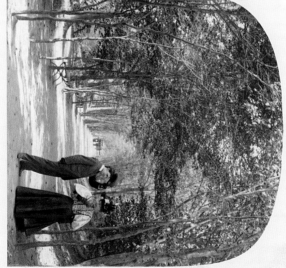

Lover's Lane, Central Park

Trefoil Arch

Central Park was designed as a pastoral landscape in the English romantic tradition and provides the ideal place for strolls with children and friends— along its many walkways, over its bridges, and under its arches. Calvert Vaux and Jacob Wrey Mould designed more than forty bridges for the park. The Trefoil Arch, constructed in 1862, with its stone trefoil pattern and cast iron railing, is among the park's most ornate archways. By 1874 there were already over twenty-eight miles of pedestrian pathways but only fifteen miles of bridle trails and carriage drives. The construction of the park was a massive public works project and involved around twenty thousand laborers. Nearly three million cubic yards of soil were moved, much of it by blasting, and around 270,000 trees and shrubs planted. The park first opened to the public in winter 1859 when thousands skated on the lakes that had formerly been unusable swamps.

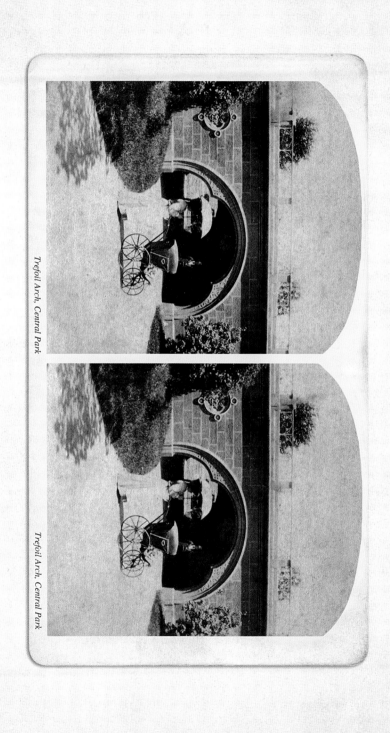

Trefoil Arch, Central Park

Trefoil Arch, Central Park

Group in Central Park

In 1853 the city of New York was authorized by the state legislature to use the power of eminent domain to acquire 778 acres of central Manhattan. In 1863 this was expanded to 843 acres. The landscape was transformed to provide New Yorkers of all classes with a place for leisure. A family outing in the park might include vigorous walks through wooded areas, as well as leisurely strolls along landscaped paths. Olmsted and Vaux used many features of the natural landscape such as these rugged rocks and the existing swamps and bluffs, which luckily had proved problematic for private development. However, about 1,600 people living in shacks and rough shanties, mostly German gardeners and Irish pig farmers and later an African-American community known as Seneca Village, had to be displaced so the park could be created.

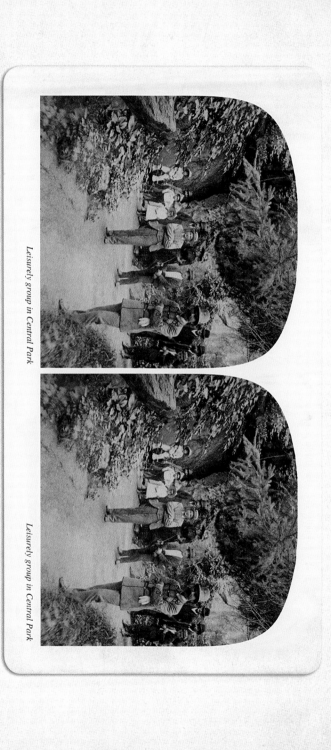

Leisurely group in Central Park

Leisurely group in Central Park

May Day Party, Central Park

May Day celebrations, held on the first day of May, began in 1886. In New York, May Day kings and queens led the parade into Central Park where maypoles were decorated with ribbons and flowers and the children had lunch and ice cream. The May Day children danced and sang songs including "All Around the Mulberry Bush." Initially group picnics were banned in the park, and schoolboys forbidden to play ball, but continuing protests from ordinary New Yorkers forced the relaxation of rules. In the 1880s working class people at last were rewarded by concerts on Sundays—their only day off.

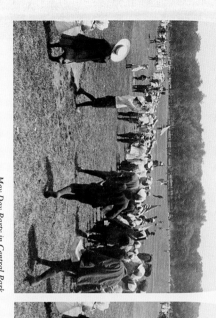

May Day Party in Central Park

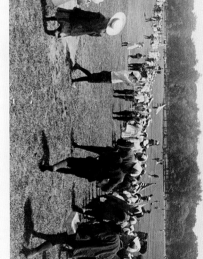

May Day Party in Central Park

Limited Express in Central Park

For children a day in Central Park could be spent running and playing or enjoying some of the park's other diversions, after the authorities relaxed the rules. Depending on the season, there was ice-skating and sledding or picnics and ice cream. For these children, dressed for a proper park outing, it was a day to ride the *Limited Express*. In 1871 the zoo was made a permanent feature and quickly became the biggest attraction in the entire park. The open spaces and fresh air of the park were vitally important for the health and welfare of the many immigrants living in crowded surrounding neighborhoods, and around the turn of the twentieth century Central Park visitor numbers reached an all-time high. Many progressive reformers lobbied for active recreation facilities for poor and working class New Yorkers to aid their welfare and health.

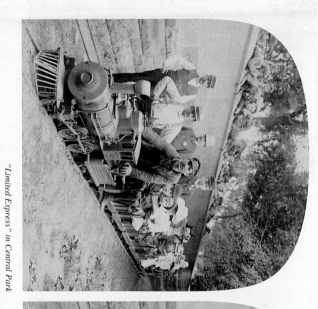

"Limited Express" in Central Park

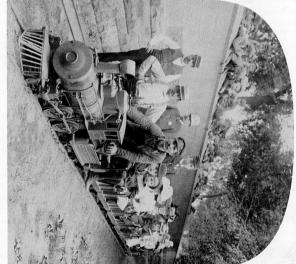

"Limited Express" in Central Park

High Bridge

Opened in 1848, High Bridge was built as part of the Croton Aqueduct system to transport water from the Croton River in Westchester County to Manhattan. Considered a major engineering feat, High Bridge crosses the Harlem River, joining the boroughs of Manhattan and the Bronx. Modeled after Roman aqueducts and built of stone masonry, High Bridge was designed by the engineer John Bloomfield Jervis (1795–1885). The water traveled over forty miles before being delivered to New York City residents for their drinking and bathing needs.

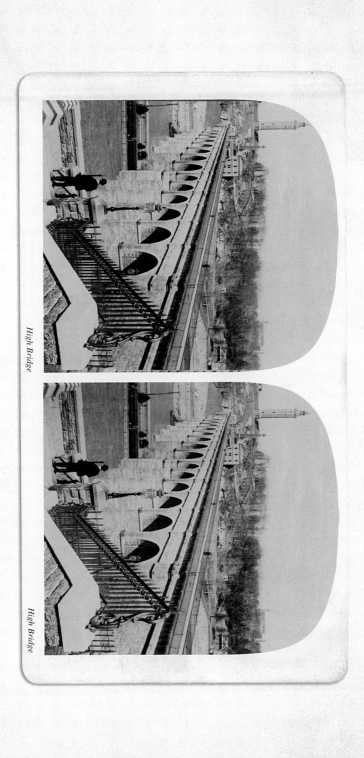

High Bridge

High Bridge

Speeding on Harlem River

At the Harlem River Speedway, pedestrians along its tree-lined walkways enjoy a stroll while viewing the horses and watching the sights. The Harlem River Speedway was built in 1900 after horse owners lobbied extensively for it to be used for fast-trotting horses, but it opened for carriages only and extended for two and a half miles along the west bank of the Harlem River in Manhattan, from West 155th Street to West 208th Street. Later the racing of drays and sulkies was permitted. This level and straight stretch of roadway became a popular spot for racing the steeds of wealthy New Yorkers safe from the danger of other types of road traffic. Previously any dignitaries wanting to race their horses—people such as Commodore Vanderbilt, Colonel Kip, and Russell Sage—would do so along the part of Seventh Avenue between Central Park and the Harlem River.

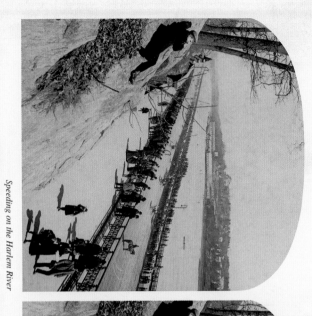

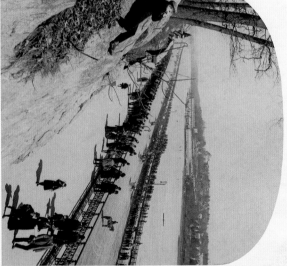

Speeding on the Harlem River

Speeding on the Harlem River

Harlem River

The Harlem River, which flows between the East River and the Hudson River for eight miles between the boroughs of the Bronx and Manhattan, provides New Yorkers with a wide variety of outdoor activities and recreational opportunities. Dozens of villages grew around scenes like this along the northern reaches of the Hudson River toward Albany. Many of the villages built around ferry ports and landings are not very different in appearance today, but this early view of Manhattan is long gone. The Harlem River has traditionally been used by rowing crews from New York University, Columbia University, Manhattan College, and Fordham University for practices and races.

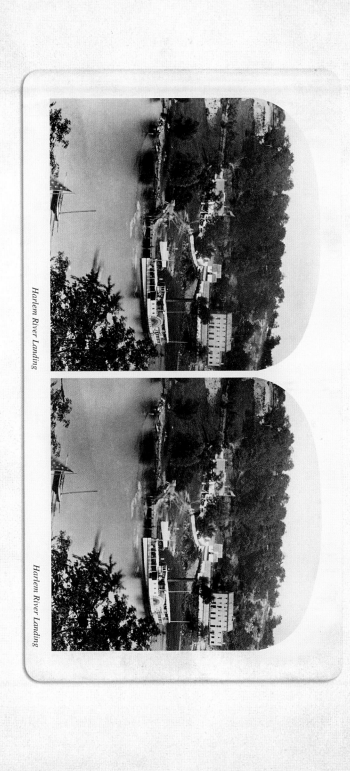

Harlem River Landing

Harlem River Landing

Grant's Tomb

Located at 122nd Street in Riverside Park, this memorial to Ulysses S. Grant houses tombs for General Grant and his wife, Julia Dent Grant. The nation revered Grant as the victorious Union commander of the Civil War. From 1869 to 1877, he served as the eighteenth president of the United States. Although not a New Yorker, this location was chosen because Grant had become fond of the city and its inhabitants and also because it was convenient for Mrs. Grant to visit. The tomb, constructed from granite and marble, is the largest mausoleum in North America, and was designed by architect John Duncan and completed in 1897. Over one million people attended the opening ceremony on April 27, 1897. The monument is inscribed with the words "Let Us Have Peace." It was paid for by public subscription. Over a million people had attended Grant's funeral parade in 1885, which wound for seven miles and included President Grover Cleveland and his cabinet, almost every congressman, all the Supreme Court justices, as well as Confederate and Union generals riding together. The parade for the dedication ceremony was almost as equally well attended, but this time headed by President William McKinley.